MW01505618

IMAGES
of America

JAMAICA BAY

A 1901 Board of Public Improvements map shows central Jamaica Bay, where the Long Island Rail Road trestle crossed. The Broad Channel Station fueled the growth of what is now the only inhabited island in the bay. Beach Channel Station, the next stop to the south, no longer exists. (Courtesy Anthony Correia and Queens Borough Public Library/Long Island Division.)

On the cover: With his belongings in tow, a man watches as homes on Ruffle Bar are burned. Parks commissioner Robert Moses ordered several islands evacuated in the early 1950s to create the park now known as the Jamaica Bay Wildlife Refuge. (Courtesy Ed Clarity and Dan Mundy.)

IMAGES
of America

JAMAICA BAY

Daniel M. Hendrick

ARCADIA
PUBLISHING

Copyright © 2006 by Daniel M. Hendrick
ISBN 978-0-7385-4559-2

Published by Arcadia Publishing
Charleston, South Carolina

Printed in the United States of America

Library of Congress Catalog Card Number: 2006924870

For all general information contact Arcadia Publishing at:
Telephone 843-853-2070
Fax 843-853-0044
E-mail sales@arcadiapublishing.com
For customer service and orders:
Toll-Free 1-888-313-2665

Visit us on the Internet at www.arcadiapublishing.com

Brant geese are silhouetted against the shimmering waters of Jamaica Bay. (Courtesy Daniel P. Derella.)

CONTENTS

ACKNOWLEDGMENTS

Jamaica Bay holds a special place in the hearts of many who live, work, and play in the area. This book would not exist without their expertise and assistance.

Among the many who lent a hand with photographs and historical facts were the late Bob Panico, U.S. Navy photographer, whose works were donated to the National Park Service by Rose Panico; Leonora Gidlund and Michael Lorenzini of the New York City Municipal Archives; Lisa DeBoer of the Brooklyn Public Library; Susan Locke, publisher of the *Wave*; James Driscoll and Richard Hourahan of the Queens Historical Society; historian Jeffrey Kroessler, who coined the name of this book's third chapter; the Library of Congress; Roy Fox and King Manor Museum; Joseph Lanzone; Dan Mundy, president of the Jamaica Bay Ecowatchers; Barbara Toborg and the Broad Channel Historical Society; Leander Shelley; Vito Turso, deputy commissioner of the New York City Department of Sanitation; Douglas Greeley, deputy commissioner of the New York City Department of Environmental Protection; Maureen Wren, of the New York State Department of Environmental Conservation; Daniel P. Derella; Fred Kress; and the *Queens Chronicle*, Mark Weidler, publisher.

Several individuals and organizations were linchpins in this book's preparation and are owed special thanks. They are Jan Schulman; photographer Anthony Correia; John Hyslop, Erik Huber, and Judith Todman of the Long Island Division of the Queens Borough Public Library; Don Riepe, director of the Northeast Chapter of the American Littoral Society; John Lincoln Hallowell and the National Park Service; and especially Rockaway historian Emil Lucev. I would also like to thank my partner, James G. Van Bramer, for his editing, patience, and encouragement.

The following written sources helped in preparing this book and offer further reading: W. W. Munsell and Company's *History of Queens County*; *Jamaica Bay: A History*, by Frederick R. Black; *Looking Through Life's Window*, by Henry Meyer; *The Power Broker*, by Robert Caro; *Old Queens, N.Y. in Early Photographs*, by Vincent F. Seyfried and William Asadorian; *First Across!*, by Richard K. Smith; and *Brooklyn's Flatlands*, by Lee Rosenzweig and Brian Merlis.

—Daniel M. Hendrick

INTRODUCTION

Looking at Jamaica Bay today, there are few clues of its rich and storied past. A mostly shallow half-circle of water pockmarked with marshes, the architecture that lines the bay's shores is uninspiring. Its flat expanse is broken only by a few hills—former landfills now covered with grass. Some of the hundreds of thousands of nearby residents like to fish or swim there, but most do not, fearing contamination or the unfamiliar. Most people who see the bay have only a fleeting relationship with it, as their airplanes arrive and depart from JFK Airport on the northeastern shore.

Few realize that Canarsie and Rockaway Indian tribes once lived on the bay, or that during the Revolutionary War, British troops marched on neighborhoods where row houses and corner delicatessens are today. In a place where shellfish harvesting has been banned for eight decades, it is difficult to imagine the taste of prized Jamaica Bay oysters or envision a thriving industry that once employed 1,500 people. Perhaps the most fascinating chapter in Jamaica Bay's past was its aborted transformation into what would have been the largest deep-water port in the world.

Jamaica Bay has been the setting for many history-making moments. The world's first successful transatlantic flight departed over the bay on May 8, 1919, and arrived more than three weeks later in Great Britain. The Rockaway Beach Hotel, billed as the world's largest at nearly a quarter-mile long, only partially opened before being sold for scrap. The Marine Parkway Bridge, which spans Rockaway Inlet between Brooklyn and Queens, was the largest highway lift span in the world when it opened in 1937. Big-band icon Guy Lombardo lost the 1947 American Power Boat Association Gold Cup race here; rumor has it that a piece of driftwood thwarted his chances. Floyd Bennett Field was the Big Apple's first municipal airport and an important military base during World War II. The aviation momentum continued with the construction of New York International Airport, now John F. Kennedy International Airport (JFK). Since opening in 1947, it has been the nation's welcome mat for millions of travelers and the backdrop for modern-day tragedies, most recently the crash of American Airlines Flight 587 in November 2001.

Over the years, the bay has seen its share of controversy. Men were imprisoned in the 1700s for fishing without permission. "Garbage Bay" was a popular nickname in the early 20th century because of the many dumps here. Master planner Robert Moses, widely praised for saving the bay from becoming an industrial park, fostered pockets of intense poverty on its shores. Immigration has made parts of Queens and Brooklyn the Lower East Side of today, with overcrowding and social tension. Environmental abuses have diminished the bay's ecological integrity.

Yet the pull of Jamaica Bay—with its ocean breezes, lapping waters and legendary fishing—is as strong today as it has ever been. In fact, its role as a sanctuary within the restless metropolis of New York City has only grown more vital with time. As residents, government officials and nature lovers ponder the bay's future, one can only hope that a look back at its rich history will deepen their appreciation of this special place.

The Dutch first began their activities near Jamaica Bay in 1636. They first rented, and later bought outright, lands from American Indian tribes. With their marks on this 1665 deed, Sachem Wametappack, Minnequaken, Attewaram, Oramysy, Rammyeraen, Panwangum, Kameneck, and Wanclyck transferred Canarsie to the Town of Amersfoort in 1665. The price was 600 white wampum, a coat, a pair of stockings and shoes, two cans of brandy, and one-half barrel of beer. (Courtesy New York City Municipal Archives.)

One

BEGINNINGS

The first permanent settlements on the bay belonged to two closely related American Indian tribes of the Metoac confederacy. The Canarsie predominated on the western and northern shores, while the lands of the Rockaway included the eastern shores and the Rockaways. Both tribes spoke Algonquin languages. They relied on the bay's natural bounty of finfish and shellfish and hunted elk, bear, and beaver.

After claiming parts of western Long Island, Manhattan, and the Hudson Valley for the province of New Netherlands, the Dutch began settling Jamaica Bay's western shore in 1636. They called their first settlement Achtervelt, later Amersfoort, or simply "de Baye." Over the next three decades, Europeans bought the American Indian title to nearly all of modern day Brooklyn and Queens. The natives did not relinquish their use of the land entirely, but soon found themselves hemmed in by fences and farmhouses, and their culture declined.

The English conquest of New Netherlands in 1664 prompted the renaming of Dutch settlements and the expansion or creation of others, including Flatlands, Jamaica (from the Algonquin word for "beaver"), and Hempstead. English became the common language; otherwise the transition to the new crown was a largely uneventful one for people in these parts.

A century later, the Revolutionary War brought British and American troops into conflict in towns nearby. After Sir Henry Clinton and his redcoats forced the Americans to retreat in the August 1776 Battle of Long Island, the area remained under British control until the end of the war in 1783.

Despite changing governments twice, life on Jamaica Bay changed little during the first two centuries after colonization, in large part due to the inaccessibility of its salt meadows. Grain, grist, and saw mills operated on the streams, while dairy and crop farming engaged most hands. Fishing supplemented residents' diets, and did not have the commercial nature that it would take on in subsequent years.

This sketch by Eugene Armbruster shows the general distribution of American Indian tribes around 1620. Historical literature refers to 13 sites within two or three miles of the bay where they lived. At least three sites—Ryders Pond, Bergen Beach, and Aqueduct—have yielded significant artifacts. (Courtesy Queens Borough Library, Long Island Division, Eugene Armbruster Photographs.)

This Native American burial was excavated by the Flushing Historical Society in 1939, a half-mile east of the Aqueduct race track. Around the edge of the bowl-shaped pit was a row of small posts, which were probably intended to keep animals away. The Belt Parkway now runs directly over the site. (Courtesy Queens Borough Public Library, Long Island Division, Borough President of Queens Photographs.)

Native American sites near Jamaica Bay were evidenced by large shell deposits, charcoal, flint chips, animal bones, and bits of pottery. Here Matt Schreiner holds an artifact at the Three-Mile Mill site, in modern-day South Ozone Park, which was being excavated in 1938. (Courtesy Queens Borough Public Library, Long Island Division, Ralph Solecki Photographs.)

Springfield Pond, seen here looking north, was another native site explored, and is located in today's Springfield Gardens. The area of interest was on the left side of the pond. (Courtesy Queens Borough Public Library, Long Island Division, Ralph Solecki Photographs.)

For 2,600 guilders, Cornelius Janszen Vanderveer bought a 100-acre farm in Midwout in 1678. He and his son-in-law built this grist mill on the north shore of Fresh Creek, which came into the hands of his son Dominicus and later his grandson Cornelius. (Courtesy Queens Borough Library, Long Island Division, Eugene Armbruster Photographs.)

This 1675–1676 homestead reflected the noble lineage of its builder, Jan Martense Schenck van Nydeck. One theory relating to Capt. Schenck is that he built a wharf on Mill Island (now Bergen Beach) and commanded many of the trading vessels carrying goods between Holland and New Netherlands. Some historians, however, see little evidence to support the theory. (Courtesy Library of Congress.)

According to tradition, the Schenck House was framed by a ship's carpenter, presumably using old beams from the hull of a ship wrecked in the mid-17th century. Such beams can be seen in the east end of the living room, photographed in 1934. (Courtesy Library of Congress.)

In the 1650s, Pieter Claesen moved into this house, located in Nieuw Amersfoort on a stream leading into Jamaica Bay. The one-story shingled farmhouse is believed to be the oldest standing house in New York State, and one of the oldest wooden structures in the country. Claesen's surname was anglicized to Wyckoff after the British took control in 1664. (Courtesy Library of Congress.)

By 1672, Pieter Claesen Wyckoff and his wife Grietje had 10 children, all living in the small, one-room house. Eventually, the original room served as the kitchen, while a late 1600s addition became a living area. Although Claesen arrived in New Netherlands as an illiterate indentured servant, he died in 1694 as one of the largest landowners in the area. (Courtesy Library of Congress.)

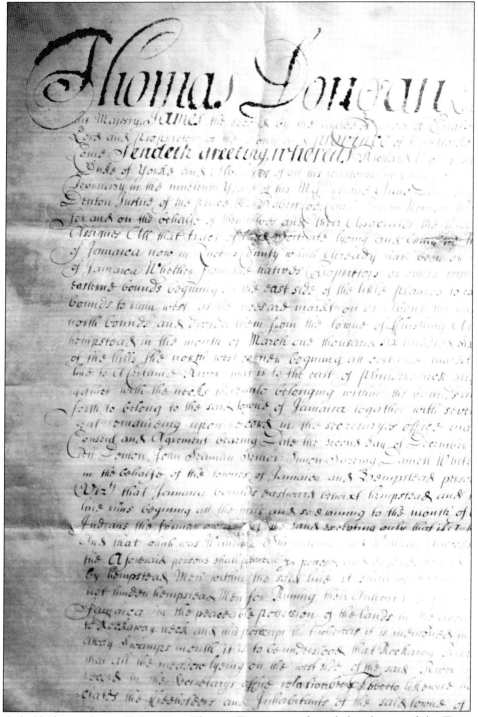

On behalf of King James II, Lt. Gov. Thomas Dongan confirmed the charter of the Town of Jamaica on May 17, 1686. It specified that "Jamaica bounds shall run to the Rockaway swamps mouth," giving the neighboring Town of Hempstead the patent to the Rockaway Peninsula. (Courtesy Anthony Correia and Queens Borough Public Library, Long Island Division.)

The Reverend Johannes Megapolensis organized the congregation of the Dutch Reformed Church of Flatlands in 1654. The original octagonal, shingled church built in 1663 was replaced in 1848 by the Federal-style landmark building that exists there now. (Courtesy Daniel Hendrick.)

Many headstones at the Dutch Reformed Church of Flatlands's cemetery predate the Revolutionary War, offering a "who's who" of original settler life. Influential families like the Lotts, the Wyckoffs, and the Schencks—like this descendant of Capt. Jan Martense Schenck—are buried here. (Courtesy Daniel Hendrick.)

Owned by Nicholas Schenck, the grandson of Capt. Jan Martense Schenck, this 1770–1775 farmhouse was noted for its gambrel roof, with two slopes on either side and the lower slope having the steeper pitch. It was located at the foot of modern-day Remsen Avenue in Canarsie Park, before being dismantled and reassembled at the Brooklyn Museum. (Courtesy Library of Congress.)

Richard Cornell, a wealthy ironmaster, moved into what was the first homestead in the Rockaways in 1690. Cornell bought the Far Rockaway property from Capt. John Palmer, who obtained it from the Rockaway tribe in 1685. The Cornells were farmers, who employed black house servants and slaves. The homestead was demolished in the 1830s for the Marine Pavilion Hotel. (Courtesy the Wave.)

The road now known as Kings Highway is one of the oldest in the country, built along paths used by the Canarsie Indians. At one time, it stretched from Brooklyn Heights to Bay Ridge, and linked Kings County's earliest settlements. The highway played a key role in the Battle of Long Island on August 26, 1776. (Courtesy Daniel Hendrick.)

4530 PRESBYTERIAN CHURCH.
ESTABLISHED 1662 JAMAICA, L. I. ILLUST. POST CARD CO.

The churches nearest to the bay's northern and eastern shores were in the Dutch settlement of Rustdorp, which later became Jamaica. The Old Stone Church was Jamaica's first, and served as a common house of worship for the Dutch and English from 1699 until 1702. In 1813, the church was replaced with the current First Presbyterian Church, left, a block away, at what is now Jamaica Avenue and 163rd Street. (Courtesy Queens Historical Society.)

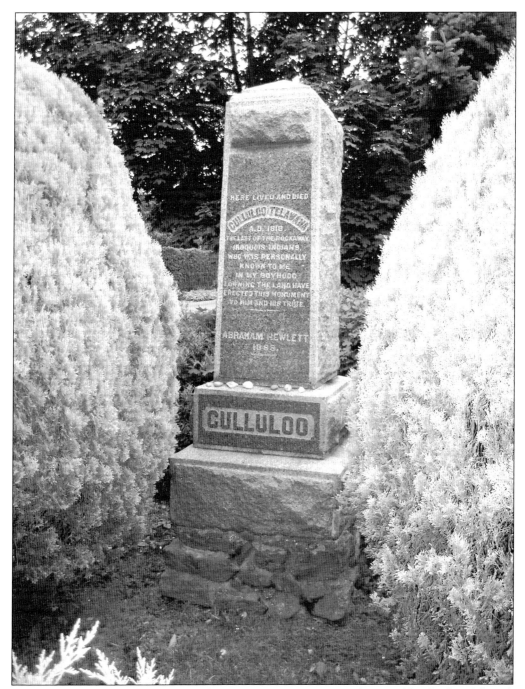

Abraham Hewlett erected the Culluloo Monument in 1888, in honor of his boyhood friend. Hewlett believed Culluloo Telewana to be the last of the Rockaway tribe, although some historians believe he was an escaped slave. The monument was originally located on Broadway in Woodmere, and moved to nearby Woodsburgh when Broadway was paved. Telewana's body, however, remains buried underneath the roadway. (Courtesy Daniel Hendrick.)

Map of the Progress of his MAJESTYS ARMIES in NEW YORK, During the late CAMPAIGN Illustrating the Accounts Publish'd in the London Gazette.

This *London Gazette* map accompanied news dispatches on the Revolutionary War in 1776. After the decisive Battle of Long Island—when Washington retreated with his troops from Brooklyn to New York—the British dug in for a long-term occupation under Sir William Howe. When

they finally left in 1783, the evacuating troops left behind considerable destruction and divided sentiments among residents. Many Loyalists even moved away to avoid confrontation with their neighbors. (Courtesy Queens Borough Public Library, Long Island Division, Maps Collection.)

In the 17th century, Dutch settlers built mills that harnessed the power derived from changing tides to grind wheat into flour. This millstone may have belonged to the tidal mill of the Gerritsen family, built sometime between 1688 and 1756. The millstone is located on a walking trail opposite the entrance to Floyd Bennett Field. (Courtesy Daniel Hendrick.)

This 1895 view shows the Hendrick I. Lott House, which was built in 1800 upon remnants of the home Johannes Lott built in Flatlands in 1720. The family's property extended from Kings Highway south to Jamaica Bay. It is one of 14 Dutch Colonial farmhouses remaining in Brooklyn. (Courtesy Queens Borough Public Library, Long Island Division, Eugene L. Armbruster Collection.)

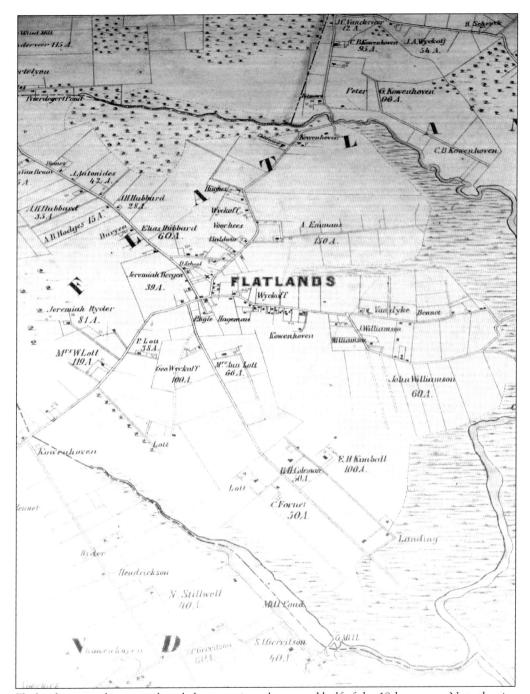

Flatlands retained its agricultural character into the second half of the 18th century. Note the size of the lots on this 1852 map—measuring 15 to 150 acres—and the names that gave rise to places familiar today like Wyckoff, Hubbard, Lott, and Gerritsen. (Courtesy Queens Historical Society.)

Rufus King, an author of the U.S. Constitution and one of New York's first U.S. senators, lived in this home in Jamaica from 1805 to 1827. Best know for his passionate stance against slavery, King also owned 40 acres on the Rockaway Peninsula to obtain salt hay for his livestock. (Courtesy Queens Historical Society.)

Born the son of a hotel keeper in Jamaica in 1815, James Remsen bought 28 acres of Rockaway beachfront for $550 in the 1850s. He opened the Seaside Hotel the following year—portending the area's transformation into a sprawling summertime resort. (Courtesy W. W. Munsell and Company.)

Two

INDUSTRIALIZATION AND PLAYGROUND

The European settlers who displaced the Canarsie and Rockaway tribes from Jamaica Bay's shores would have had little trouble recognizing it more than two centuries later. There was as a larger population, to be sure, but farming was still the main occupation, no bridges yet spanned the bay, and the islands and meadows remained where they had been for years.

Rapid modernization and industrialization in the mid-19th century changed that. Fish-oil and fertilizer factories appeared on Barren Island, initiating the bay's role as a place for disposing of the unwanted. A commercial fishing industry opened for business, with Canarsie as its hub. Stables disappeared from Mill Island, replaced by landfill to extend Flatbush Avenue. Developers eyed Jamaica Bay's northern and eastern shores for housing.

Railroads ushered in the most sweeping changes. The Brooklyn and Rockaway Beach Railroad fueled the growth of Canarsie, and to a lesser extent Bergen Beach, into resorts. Ferry service connected the two ports with the Rockaway Peninsula to meet vacationers' increasing demand. A trestle later spanned the bay from Remsen's Landing to Hammels. Stops along the way became destinations in their own right, with hotels, fishing clubs, and cottages clinging to the grassy hummocks.

In many ways, the years between the Civil War and World War I on Jamaica Bay were golden. Before the pressures of a burgeoning population had set in, the best weakfish on the East Coast could be had just moments away from nightclubs and casinos.

With the exception of Barren Island, Bergen Island, and Canarsie, Dripps's 1852 map shows no property owners directly on the bay. The white areas in Flatlands denote farms, while the patch in "Jamaica South," at the top of the map, is unowned salt meadow mowed to feed livestock.

26

The thick marshes were largely responsible for keeping development at bay for so long. (Courtesy Queens Historical Society.)

James Remsen's Seaside Hotel emerged as one of the best-known accommodations on the Rockaway Peninsula in the late 1850s. The three-story hotel had room for 300 guests with a restaurant on the main pier. It was destroyed in a fire on September 13, 1892, exactly one week before a much larger fire would engulf the entire neighborhood. (Courtesy W. W. Munsell and Company.)

Shellfish harvesting in Jamaica Bay began to take on a commercial character in the 1860s, after the planting of seed oysters became a common practice. Oysters were harvested from September until December, with many sold in Manhattan markets, like this one seen in 1870. (Courtesy Library of Congress.)

The smokestacks at rear were the hallmarks of Barren Island, where as many as 26 companies operated between 1859 and 1934. At its height, the island's population numbered 1,500, enough to sustain a church and school. The main products were fertilizers from dead horses, and fish oil, which was used to mix paints and tan leather. (Courtesy Queens Borough Public Library, Long Island Division, Illustrations Collection.)

Barren Island's topography contributed to its early development. At low tide, men and livestock could reach it from the mainland, while larger vessels could approach the south side. This 1877 map records the location of several structures, including the remnants of two factories that opened in the late 1850s and a hotel on the eastern tip. (Courtesy Anthony Correia and Queens Borough Public Library, Long Island Division.)

View Along Bayswater, Far Rockaway, L. I.

At the beginning of the 20th century, Bayswater was an exclusive enclave that attracted affluent Germans. The house at the far left was Breezy Point, a mansion belonging to financier Louis Heinsheimer that measured 175 feet long. It was designed by Rodolphe Daus, a Mexican-born architect who trained at the Ecole des Beaux-Arts in Paris. (Courtesy Emil Lucev.)

After ferry service from Canarsie began in 1866, several Rockaway hoteliers extended their landing facilities into the tidal stations. The longer piers made it easier for large ships to bring passengers to their respective establishments. This 1877 map shows landings at, from left to right, Neptune Hotel, Seaside House, Holland's, Eldert's, and Hammels. (Courtesy Anthony Correia and Queens Borough Public Library, Long Island Division.)

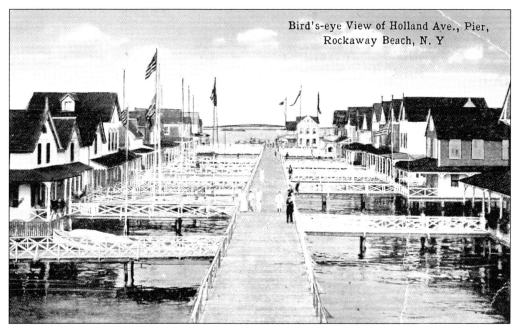

Bird's-eye View of Holland Ave., Pier, Rockaway Beach, N.Y

Holland Pier stretched 900 feet from the railroad in Rockaway near Beach 92 Street. Winter storms seriously damaged the pier in 1884, but it was quickly repaired and several fishing and boat clubs were built with connecting walks before 1898. (Courtesy Emil Lucev.)

ADAM J. STAHLE PROP. DIAMOND POINT HOTEL AND PIER, CANARSIE L.I.

After the Brooklyn and Rockaway Beach Railroad opened in 1865 and ferry service to the Rockaways began, Canarsie Landing began catering to the summer crowds. Several hotels emerged, including the Diamond Point Hotel and Pier, which was on East Ninety-second Street adjacent to the Golden City Amusement Park. (Courtesy Emil Lucev.)

Billed as the largest hotel in the world, the Rockaway Beach Hotel only partially opened in 1881. It was 1,188 feet long, had several hundred rooms and a main staircase so grand that 40 people could walk up arm-in-arm. Financial problems forced the hotel to be sold for $30,000 in 1884. It was promptly dismantled, with some parts used in other hotels nearby. (Courtesy the Wave.)

The Seaside Property,

SEA SIDE STATION, ROCKAWAY BEACH, L. I.

The Most Desirable Business Sites on Rockaway Beach for sale or to let.

——OCEAN AND BAY FRONT PLOTS TO LET——

HOTELS AND COTTAGES FURNISHED AND UNFURNISHED.

Wainwright, Remsen and Tator, Owners.

J. W. WAINWRIGHT, AGENT.

Under the auspices of James Remsen and his business partner William Wainwright, Seaside grew into a sprawling residential and business community, which this June 1907 newspaper advertisement promotes. Wainwright was able to convince steam-line companies to come to the Rockaways directly from Manhattan, vastly increasing visitors. (Courtesy the Wave.)

In April 1877, the supervisors of the town of Jamaica gave James M. Oakley, above, a 99-year lease for a right-of-way to construct a trestle crossing Jamaica Bay. Oakley's New York, Woodhaven, and Rockaway Railroad opened the five-mile track on August 26, 1880, and carried 65,000 passengers the first day. He sold his interest in 1886 to the Long Island Rail Road, which assumed control of the line the following year. (Courtesy W. W. Munsell and Company.)

After taking over the Woodhaven and Rockaway Line, the Long Island Rail Road established a station at Goose Creek in 1888. It was the first station on the trestle, located 4,200 feet south across Grassy Bay from the mainland, on the northernmost marsh crossed by the tracks. (Courtesy Emil Lucev.)

Named for a channel at the geographic center of the bay, the Raunt grew into a thriving fishing colony after a rail station opened in 1888. At its height, the Raunt counted more than 100 structures. The settlement declined after a 1931 fire, and the island is now part of the Jamaica Bay Wildlife Refuge. (Courtesy Library of Congress.)

The Broad Channel Station, the third along the trestle, was located on the shore of Big Egg Marsh, about three-quarters of a mile south of the Raunt. Prior to its 1881 opening, only a few shacks used by fishermen were on the marshy island. Within a year, four hotels and a full-fledged fishing station were built. (Courtesy Emil Lucev.)

This view of the Long Island Rail Road was taken in 1895, looking south toward Hammels Station from Beach Channel, the last station along the trestle. The drawbridge, one of three on the islands, was 50 feet tall and made of iron. (Courtesy Emil Lucev.)

The cross-bay trestle had a double track that rested on more than 1,700 piles spaced every 12 to 17 feet across the route. The top of the railroad averaged nine feet above mean high water level. This view was taken in 1914 from the Howard's Landing station, looking south toward the many buildings on Goose Creek. (Courtesy Queens Borough Public Library, Long Island Division, Public Service Commission Photographs.)

Ramblersville, L. I.

After the Civil War, the tiny community of Ramblersville appeared on Hawtree Creek. The cluster of 10 houses, which were built on stilts over the water and connected by walkways, attracted mostly oystermen and clam diggers. (Courtesy Emil Lucev.)

Two men shuck oysters, probably in Canarsie, around 1900. Although data about Jamaica Bay's shellfish industry are somewhat unreliable, a 1904 report found 150 men employed in clamming and oystering. By 1916, that number rose to 1,500. (Courtesy Joseph Lanzone.)

A man docks boats carrying bushels of oysters in 1900, probably near Canarsie. According to one 1892 estimate, a typical summer Sunday would see more than 1,000 fishing boats anchored in the bay, especially near prized spots off Broad Channel. (Courtesy Joseph Lanzone.)

Springfield Dock, located near the end of today's Brookville Boulevard, was one of the few settlements on the bay's eastern shores at the beginning of the 20th century. Skiffs from the dock routinely took passengers from Keppler's Hotel to the Rockaway beaches. (Courtesy Queens Historical Society.)

Boat House at Rockaway Beach, N. Y.

The piers that stretched from the Rockaways into Jamaica Bay were not just for docking ships. They often supported businesses and homes, like these boathouses seen on Hammels Pier in 1911, which extended from what is now Beach 85 Street. (Courtesy Emil Lucev.)

BEAUTIFUL WAVE CREST LAKE, FAR ROCKAWAY, L. I.

Through the first decade of the 20th century, shallow Wave Crest Lake stood where today's Briar Place is, and a stream that ran along Deerfield Road connected it with what is now Norton's Basin in Bayswater. The lake was filled in around 1911 to make way for hotels and bungalows. (Courtesy Queens Historical Society.)

The names of places around the bay were often determined by their characteristics or inhabitants. Historians say this point, located in today's Inwood, probably either had dark sands or was home to African Americans after the Civil War. Yellow Bar Hassock, at the center of the bay, was named for the color of its sands. (Courtesy Anthony Correia and Queens Borough Public Library, Long Island Division.)

The opening of railroads in the second half of the 19th century significantly reshaped Jamaica Bay. Where there were only mills and a handful of villages a half-century before, this 1900 map shows how quickly Canarsie, Bergen Beach, the Rockaways, and communities on the

northeastern shore had grown. The map also details the locations of Long Island Rail Road stations that disappeared more than 50 years ago. (Courtesy Brooklyn Daily Eagle.)

Rapid development of Bergen Island began after the Germania Real Estate and Improvement Company bought it in 1892. Streets from Avenue T to Avenue Z were constructed, as was an amusement park and Ferris wheel, which opened in 1894. The area began to be known as Bergen Beach in 1899. (Courtesy Joseph Lanzone.)

By 1905, Bergen Beach emerged as a small resort, complete with ferry service to Canarsie and trolley connections. The Percy Williams Amusement Park opened that year, welcoming 32,000 visitors to various attractions that included a carousel. The popularity of Coney Island eventually eclipsed that of Bergen Beach and the amusement park closed in the 1920s. (Courtesy Joseph Lanzone.)

The Bayswater Yacht Club was distinctive for the large white "BYC" letters at its entrance. The clubhouse, which measured 75 feet on all four sides, was accessed via a 360-foot-long walkway, and was located on Norton Drive between Cold Spring Road and Bayswater Avenue. (Courtesy Emil Lucev.)

Jamaica Bay Yacht Club, Hollands, Rockaway Beach, L. I.

The Jamaica Bay Yacht Club was one of the largest on the bay, and known for the many boating races it sponsored. The club was founded in the late 1890s at Beach 90 Street in Rockaway and closed in the 1920s. Note the large sewer pipe in the foreground. (Courtesy Emil Lucev.)

Passengers debark from the *General Slocum*, left, at the Seaside Dock in 1899. At right is the *Grand Republic*. Five years later, the *General Slocum* would catch fire while on a Sunday school outing on the East River, killing 1,021 people—most of them women and children—just yards from shore. (Courtesy Queens Borough Public Library, Long Island Division, Frederick J. Weber Collection.)

The *Grand Republic* was among the many steamers that brought one-day summer excursion passengers from Manhattan and Brooklyn to the Rockaways in the late 19th and early 20th centuries. Owned by R. Cornell White's Iron Steamboat Company and later the Knickerbocker Steamship Company, the *Grand Republic* had a capacity of 3,700. (Courtesy Emil Lucev.)

Hotel Howard was the crowning achievement of William Howard, a Brooklyn leather manufacturer and developer. The three-story wooden structure was at the end of a pier that jutted 1,750 feet into the bay past Ramblersville. The hotel, along with a dancing pavilion and 12 houses on the pier, was destroyed by a fire on October 23, 1907. (Courtesy Emil Lucev.)

The banks of Hawtree Creek began to be developed after William Howard got permission from the city in 1909 to dredge for landfill. To the east of the creek, he built a community called Howard Estates (now Howard Beach), while to the west was Hamilton Beach. Both had summer bungalows and year-round homes. (Courtesy Emil Lucev.)

In 1882, a lawyer named Remington Vernam bought land between Far Rockaway and Rockaway Beach, building houses and laying out streets, as seen on this 1901 map. The way he signed his checks—R. Vernam—inspired the neighborhood's name of Arverne. (Courtesy Anthony Correia and Queens Borough Public Library, Long Island Division.)

Vacationers of modest means could bypass hotels for the "tent cities" that sprang up from Far Rockaway to Rockaway Point. Many of the tents, such as this one seen in 1910, were fitted with the comforts of home for extended stays. (Courtesy Library of Congress.)

Opened in 1901, the Playland amusement park became the Rockaways' best-known attraction. It had an Olympic-size swimming pool, large midway, and the Cinerama roller-coaster, seen at rear. The park closed in 1985, long after Rockaway had ceased to be a fashionable summer resort. (Courtesy Emil Lucev.)

The Rockaway Park Yacht Club was located at Beach 117 Street. The structure was the subject of a 1916 lawsuit by a neighbor, restaurateur Frank Busto, whose deed guaranteed him rights to an unobstructed view of the bay. He lost the case. (Courtesy Emil Lucev.)

Beginning in 1870, the affairs of the bay that fell under Jamaica's jurisdiction were administered from the town hall, located at the corner of Jamaica Avenue and Parsons Boulevard. It was from here that the board of supervisors leased rights to Jamaica Bay oyster beds. (Courtesy Queens Historical Society.)

Broad Channel grew faster and larger than any other island. In 1900, there were only six structures. Ten years later, there were hundreds, connected by wooden walkways. In 1914, the year before this picture was taken, the city conveyed the island's lease to Pierre Noel and the Broad Channel Corporation to make improvements for a year-round population. (Courtesy Library of Congress.)

Fishing for weakfish at Goose Creek attracted anglers from far and wide. In 1899, the island counted six fishing clubs, two saloons, and a hotel. Joe Paul's White House, seen here in 1915, was a popular establishment in later years. The buildings were eliminated by 1940, when the creek was filled in. (Courtesy Library of Congress.)

A maid washes dishes in 1918 at the Enterprise Hotel, which opened in 1899 and was connected to the Broad Channel Station by a wooden boardwalk. During Prohibition, hotels and saloons on the island proliferated since they were deemed too remote for police raids. (Courtesy Joan Christian and Broad Channel Historical Society.)

The first bridge connecting Broad Channel and the Rockaways opened in 1924. It proved to be a lifesaver for Broad Channel the following winter when a fire broke out. Local water lines were frozen, but Rockaway firemen were able to bring in their equipment over the new span. (Courtesy Emil Lucev.)

The Rockaway Point Inn and Movie House was located at the end of the 280-foot-long Reid's Landing in 1925, at the peninsula's western edge at what is now Reid Road. The sign at the end of the pier advertises Trommer's Malt Brew, a signature beer of the time. (Courtesy Emil Lucev.)

The Broad Channel Baths opened on July 4, 1925, with a 100-foot-long pool, five handball courts, 1,000 bath houses, and a cafeteria. It was located at the southwestern tip of the island, where 300,000 cubic yards of sand were used to fill in a stream. Three people are identified in this 1927 view, Sal Letke (left), Dutch (third from left), and Jimmy Ferris (fourth from left). (Courtesy Stanley Reich and Broad Channel Historical Society.)

The Belle Harbor Yacht Club, seen in a 1936 postcard, served wealthy residents from its Beach 126 Street location. The club endures to this day as a hub for socializing and community events. (Courtesy Emil Lucev.)

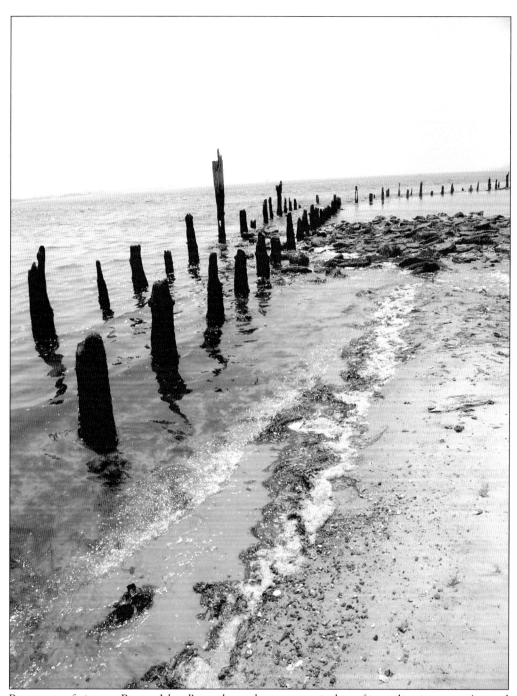

Remnants of piers on Barren Island's southern shore are reminders of its utilitarian past. Around 1900, seven or eight garbage scows would dock at the island every day to dispose of their refuse, while on weekdays at 10:00 a.m. the horse boat would arrive with dead cows, cats, dogs, and up to 50 horses. For a time, ferry service also connected the island to the Rockaways. The last of Barren Island's factories closed in 1935. (Courtesy Daniel Hendrick.)

Three

THE GREATEST PORT
THAT NEVER WAS

As docks in Manhattan and Brooklyn grew crowded and New York City's population swelled at the beginning of the 20th century, it was inevitable that Jamaica Bay would change. What some real estate developers and elected officials had in mind, however, was nothing less than a complete transformation.

Their plan called for the creation of the world's largest deep-water port, with massive, man-made industrial islands at the center. The bay's shallow waters were to be deepened for ocean-going ships, while the marshes and meadows along the periphery were to be replaced by dozens of piers, manufacturing sites, and residential communities. A network of railroads and terminals would whisk away goods. Canals would provide time-saving connections between Jamaica Bay and Newtown Creek, Flushing Bay, Gravesend Bay, and Great South Bay.

The bay had been the object of ambitious dreams for years, first by industrialist John R. Pitkin and later by men like Andrew Haswell Green, who masterminded the consolidation of New York City in 1898. The city seriously began pondering the bay's future at the urging of comptroller Edward Grout in 1905, prodded by business interests who contended that New York had outgrown its ports. With backing from the state and federal governments, the Department of Docks began fulfilling parts of the plan in 1912. Rockaway Inlet was dredged, and a main ship channel, Mill Basin, and Floyd Bennett Field were created. The work added to topographical changes made by private interests, who reclaimed marshes for residential development and dredged the bay for shipping.

The shortcomings of the improvement scheme grew more glaring as time passed. It would require extensive and expensive work to become a reality, while linchpin highways and railroads never materialized. Regional planning that emphasized cooperation over competition prevailed, fueling the growth of ports in New Jersey instead.

One of the first to see the development potential of Jamaica Bay was shoe manufacturer John R. Pitkin. In 1835, he and his brother-in-law bought three farms in the northwestern part of New Lots, which he divided into streets and named East New York. Pitkin's plan was to build a manufacturing and commercial center that could rival Manhattan. (Courtesy W. W. Munsell and Company.)

While most topographical changes to Jamaica Bay occurred at government hands, some of the earliest changes were due to private interests. The Canarsie Railroad steamships faced a consistent problem in the silting of a mile-long channel from Canarsie Landing into Big Channel. This 1888 map shows plans for dredging the channel and the placement of dikes to slow the silting. (Courtesy Queens Borough Public Library, Long Island Division.)

Andrew Haswell Green was chairman of the state commission that consolidated the five boroughs into New York City in 1898. He intentionally included all of Jamaica Bay and the Rockaways, which had been part of the town of Hempstead. A man who met Green on a train in 1900 recalled Green saying the bay "would be the greatest shipping center in the world." (Courtesy Queens Borough Public Library, Long Island Division, Portraits Collection.)

ELIZABETHPORT NEWARK JERSEY CITY HOBOKEN
BAYONNE MANHATTAN
RICHMOND UPPER N Y BAY E A

GREATER NE

BROOKLYN

CITY PARK TRINITY TERMINAL

MILL BASIN DEVELOPMENT CANARSIE MAIN CHANNEL

GREELEY TERMINAL

EXPORT TERMINAL

JAMAICA

FERRY SHIPYARD

KAWAY INLET BAY

TELAWANA PARK

BIRDS-EYE VIEW OF **JAMAICA BAY**

Portraying its probable development by showing the commercial, financial, health and recreational advantages to be gained by the citizens of Greater New York, under a zoning system as proposed by

Various embellishments appeared on maps drawn in the first three decades of the 20th century but the general improvement scheme was the same. Jamaica Bay's marshes and meadows were to be eliminated, while large islands were to be built at the center. Shipping piers would be constructed along new basins around the rim and on the islands, and rail facilities built to carry goods to consumers. This plan shows one of the more ambitious variations on the improvement

plan. It called for a canal linking Flushing and Jamaica Bays at Cornell Basin, which would have required a tunnel as it passed through the higher elevations at the center of Queens where the Grand Central Parkway is today. Planners also discussed another canal link to Great South Bay on Long Island's south shore. None of the canal projects was instituted. (Courtesy Henry Meyer.)

This early map, known as the Kingsview plan, is distinctive in calling for three islands: West, North, and South Islands. They would form the centerpiece of the port plan in most subsequent designs. (Courtesy Emil Lucev.)

In 1918, the Department of Docks gave approval to build 14 piers between Barren Island and Mill Basin. Each was 1,000 feet long, with 300-foot slips in between them. Another 16 to 18 piers were also to have been constructed between Shellbank Basin and Paerdegat Basin. The Flatbush Avenue extension began in 1913 and was completed 10 years later. (Courtesy Anthony Correia and Queens Borough Public Library, Long Island Division.)

The Jamaica Bay flag, consisting of white letters on a blue background, symbolized the concept of the bay as a future world port. It was first flown in 1911, appearing on the masts of dredgers and ocean-going vessels for VIP visits and milestone moments. The flag was also flown in European ports when a Brooklyn social club chartered the S.S. *President Harding* for a trip to Great Britain, France, and Germany in 1923. (Courtesy Henry Meyer.)

After the beginning of the 20th century, large dredgers like the *Ramblersville*, seen here around 1912, were a common sight. Much dredging and filling at the bay was done at the behest of private real estate interests; it is likely that the *Ramblersville* helped shape today's neighborhoods of Howard Beach and Hamilton Beach. (Courtesy Queens Borough Public Library, Long Island Division, Illustrations Collection.)

Brooklynite Nelson Kilmer, the primary force behind the *Jamaica Bay Advocate* weekly paper, was one of the most avid development supporters. As secretary of the Jamaica Bay Improvement Commission, he complained that "New Jersey interests" threatened to block bay development unless the Port Authority also advanced proposals for a port in Newark. (Courtesy Henry Meyer.)

One of the few existing facilities retained in the port plan was Fort Tilden, the 317-acre military post that opened in April 1917 near Rockaway Point. The fort kept a watchful eye over Jamaica Bay and the New York Harbor during World War I and II, bolstered by the most technologically advanced weaponry of the period including smooth-bore cannons, 16-inch naval rifles, and anti-aircraft missiles. (Courtesy Emil Lucev.)

Gerritsen Creek, to the east of Barren Island, was bulkheaded and dredged after the city began work on the main ship channel in 1912. Deep Creek basin, seen on this 1924 map, was never built, but Kimball Basin (today's Mill Creek) was, along with Mill Basin to the north, which was dug 1,000 feet wide and 15 feet deep. The dotted line is the Flatbush Avenue extension across Barren Island to Rockaway Inlet, which was completed in 1923. (Courtesy Anthony Correia and Queens Borough Public Library, Long Island Division.)

Dubbed the "father of Jamaica Bay" in the press, deputy dock commissioner Henry Meyer was one of the most passionate advocates for the bay's transformation. He is shown here at right, with O. O. W. Parker (left), superintendent of the marine department of the U.S. Shipping Board, and Capt. George Beebe (center). (Courtesy Brooklyn Daily Eagle.)

Following World War I, the U.S. Shipping Board's Emergency Fleet Corporation used Jamaica Bay to temporarily store more than 100 merchant ships. The first to enter the bay was the S.S. *Vinton County*, left, seen alongside S.S. *Kootenia*, on March 4, 1921. Proponents of the port plan saw this use as evidence of the bay's potential for ocean-going vessels. (Courtesy Henry Meyer.)

This 1924 map for the New York City Board of Estimate and Apportionment shows details of the basins on the northeastern shore. Bergen Basin, the site of the former Bergen's Landing, exists today and is the western boundary of JFK Airport. Cornell Basin was never created. (Courtesy Anthony Correia and Queens Borough Public Library, Long Island Division.)

Regional planning that supported new port facilities in New Jersey ultimately scuttled the plan. Ports in Newark, seen in 1939, and Elizabethtown had ample space and offered connections into the nation's trunk lines that never materialized at Jamaica Bay. (Courtesy Library of Congress.)

This adopted plan for the Improving of Jamaica Bay "offers opportunity to increase the entire Greater New York City's present existing Docking Facilities by over 50%."

ADOPTED
MAP OF JAMAICA BAY

Although the port plan was effectively dead, proponents continued to circulate designs well into the 1930s. This zoning map shows how West Island was to have three deep basins, while East Island was to be zoned for detached bungalows and dwellings. As the plan faltered, business interests looked for other ways to use the bay and unsuccessfully lobbied to have the 1939 World's Fair here rather than in nearby Corona. (Courtesy Henry Meyer.)

Four

ROBERT MOSES AND TRANSFORMATION

The theory that Robert Moses shaped New York City more than any other individual finds abundant proof at Jamaica Bay. While the port proposal was still on the city's official map and seriously considered in some quarters, Moses had other plans. In 1938, as New York City Parks commissioner, he outlined his ideas in a booklet called "The Future of Jamaica Bay." Emphasizing parks and recreation over utility, he called on New Yorkers to finally make a decision: "Jamaica Bay faces today the blight of bad planning, polluted water, and garbage dumping. Are we to have here another waterfront slum, depriving millions of future inhabitants of Brooklyn and Queens of the advantages of boating, fishing and swimming in safe inland waters?"

With financing from the Marine Parkway Authority, Moses had already begun to make his mark on the bay when it was transferred into his control in 1938. The Rockaway Improvement project remodeled the bathing pavilion at Jacob Riis Park, while the Rockaway Beach boardwalk was cleared of concessions, and the Long Island Rail Road tracks elevated above a new express highway. On the north side of the bay, Moses created the Belt Parkway, which was linked to the Rockaways via the Flatbush Avenue extension and the new Marine Parkway Bridge. On Moses's watch, sewage treatment plants were built and a wildlife refuge took shape on the islands.

Moses is due credit for preserving Jamaica Bay's natural areas, yet he is also to blame for many of its problems. He permitted the dumping of garbage in several locations to reclaim land, allowing sewage sludge to be used as fill for Marine Park and the massive Fountain and Pennsylvania Avenue landfills to rise. Moses also reshaped the social and economic fabric of the communities surrounding the bay through his control of the New York City Housing Authority. The poor were crammed into towering public housing projects he sited here, isolating them at the city's easternmost edge.

This 1937 view shows the central bay before the parks department assumed jurisdiction the following year. Thanks to the Cross Bay Road and extensive marsh reclamation, Broad Channel, in the foreground, counted a few thousand residents. The island to the northeast was the Raunt, which had several dozen structures. (Courtesy Emil Lucev.)

One of Robert Moses's first steps was to rezone the bay and its neighborhoods. The two areas in black indicated proposed industrial areas at Mill Basin and Idlewild. Areas south of the Belt Parkway were to be residential, with the waterfront and all islands reserved for recreation. (Courtesy Broad Channel Historical Society.)

Moses proposed building the Marine Parkway Bridge in 1933 to connect Flatbush Avenue in Brooklyn to the Rockaway beaches. With plans to create an industrial port still on the city's official map, Moses conceded to a lift span that gave a 150-foot clearance to ships passing below. The bridge opened on July 3, 1937, and charged a 15¢ toll. At 4,022 feet, it was the longest lift span of its kind at the time. (Courtesy Queens Borough Public Library, Long Island Division, Illustrations Collection.)

After the Brooklyn Rapid Transit Company built elevated lines to Richmond Hill and Jamaica between 1915 and 1918, the communities bordering the bay grew rapidly. This 1938 photograph shows homes on 138 Street at 115 Avenue in South Jamaica. The Van Wyck Expressway service road now runs through the area. (Courtesy Queens Historical Society.)

This smokestack was one of the last remnants of Barren Island's fertilizer, horse-rendering, garbage-disposal, and fish-oil industries. The stack was torn down to make way for Floyd Bennett Field in 1937, after the last of the island's factories closed. (Courtesy Brooklyn Public Library, Brooklyn Collection.)

The New York City Parkway Authority built the Cross Bay Bridge in 1939. A 15¢ toll was charged on the new bascule bridge, which had to be raised for boats. It was replaced in 1970 with an elevated fixed span that allowed boats to pass underneath. (Courtesy Emil Lucev.)

The Cross Bay Bridge initially had four lanes, two more than the concrete trestle it replaced, but was still prone to summer traffic congestion. It carried 10,000 vehicles a day during its first full year of operation in 1940. (Courtesy Emil Lucev.)

A new traffic separator employing classic Moses design was built at Beach Channel Drive and Beach 95 Street around 1938. It separated east-west traffic from vehicles heading to the Rockaway boardwalk. (Courtesy Broad Channel Historical Society.)

Moses hailed the "proper connections" that Beach Channel Drive established between Jacob Riis Park and the Cross Bay Bridge, yet he created a dilemma for future generations since their access to the bay was cut off. This 1938 view of the new road looks west from Beach 131 Street. (Courtesy Queens Borough Public Library, Long Island Division, Borough President of Queens Collection.)

Moses saw the Belt Parkway, which opened along the bay's northern shore in 1940, as part of a system of integrated connections that would move auto traffic throughout New York City quickly and efficiently. Moses is seen here with a model of the Battery Bridge, which he hoped to link the Belt Parkway with Manhattan. Pres. Franklin D. Roosevelt defeated the plan, asserting that the bridge would block a navigable waterway if bombed. Moses grudgingly built a tunnel instead. (Courtesy Library of Congress.)

Jacob Riis Park became vastly more popular after the Marine Parkway Bridge opened in 1937. Moses had the original bathing pavilion redesigned and built new facilities further from the shore along a newly created semicircle of sandy beach. (Courtesy Queens Borough Public Library, Long Island Division, Postcard Collection.)

As part of the Rockaway Improvement, the Long Island Rail Road elevated 39 grade crossings on the peninsula. This 1943 view in Hammels shows the new structure that carried the tracks, with an express highway underneath and on the sides. The left viaduct crosses Jamaica Bay to points north; the right viaduct heads toward Rockaway Park and Beach 116 Street. (Courtesy Queens Borough Public Library, Long Island Division, New York State Public Service Commission Collection.)

World War II delayed some of Moses's more ambitious initiatives, as the bay was put into service for the nation's defense. These men are practicing an abandon-ship drill at the Sheepshead Bay Maritime Training Center in 1943. During the war, civilians also used their boats for anti-submarine and watch patrols on Jamaica Bay. (Courtesy Library of Congress.)

Passengers debark from the Long Island Rail Road at the Raunt Station in 1945. Moses's plan to clear the islands for a park was aided by pollution, which made them less attractive. The Raunt began declining in the 1930s, and there were only 15 structures left there in 1954. The station was abandoned after the railroad trestle burned down in 1950. (Courtesy Queens Borough Public Library, Long Island Division, Illustrations Collection.)

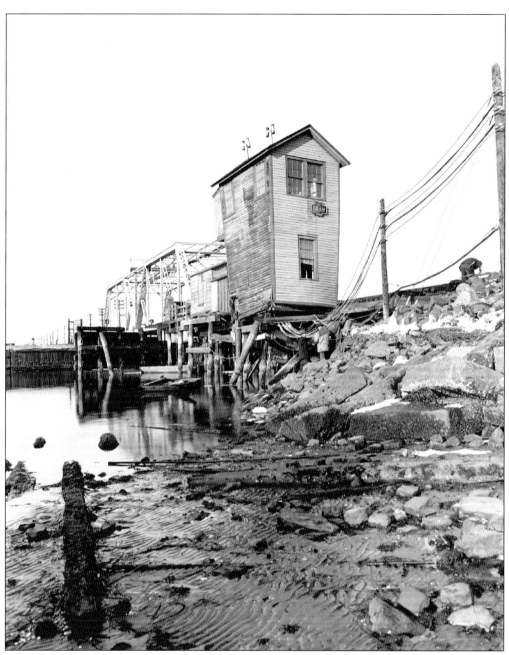

The railroad trestle across Jamaica Bay required constant and costly maintenance. Winter ice shifted the pilings out of alignment, while in the summer, shipworms bore through and weakened the wood. Human error also took its toll, such as when a boat hit the supports of the drawbridge between Beach Channel and Beach 90th Street in 1948, weakening the tower above. (Courtesy Queens Borough Public Library, Long Island Division, Illustrations Collection.)

After World War II, the city reclaimed wetlands between Gerritsen Creek and Flatbush Avenue to expand Marine Park. But the use of offensive sewage sludge as fill material drew an angry response from residents, who sued in Brooklyn Supreme Court in 1948. The city later authorized $310,000 to relocate the sludge beds and switch to sand. (Courtesy Anthony Correia and Queens Borough Public Library, Long Island Division.)

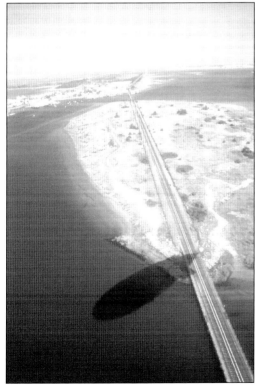

After a fire destroyed the Long Island Rail Road trestle in 1950, the city bought the line for $8.5 million and adapted it for the A and S subways. Subway Island, left, was one of two islands created by the retrofitting. Subway service across it began in 1956. (Courtesy Don Riepe and American Littoral Society.)

DEPARTMENT OF PARKS
JAMAICA BAY IMPROVEMENTS
EXISTING AND PROPOSED

JAMAICA BAY BIRD SANCTUARY
THE RESTORATION OF THE BAY TO BOATING, FISHI
SWIMMING AND NATURAL WILD LIFE

This master plan, drawn up in the 1940s or early 1950s, offers a birds-eye view of Moses's interlocking initiatives. The bird sanctuary—not yet expanded to Canarsie Pol and Ruffle Bar—dominated the islands, while parks and marinas lined the shore. Note the many public housing projects, whose placement Moses controlled. (Courtesy Broad Channel Historical Society.)

With the sharp rise in automobile traffic after World War II, the Belt Parkway was widened from four to six lanes on each side in the 1940s. Residents and Brooklyn borough president Sebastian Leone also beat back Gov. Nelson Rockefeller's plan to open it to trucks in 1971. The parkway now carries 150,000 cars a day. (Courtesy Don Riepe and American Littoral Society.)

After subway service began on June 28, 1956, from a new station at 159th Avenue, Howard Beach grew rapidly into the suburban community it is today. Rockwood Park, located to the west of Cross Bay Boulevard, appeared in the 1950s, followed by co-ops and condos in the 1980s. (Courtesy Don Riepe and American Littoral Society.)

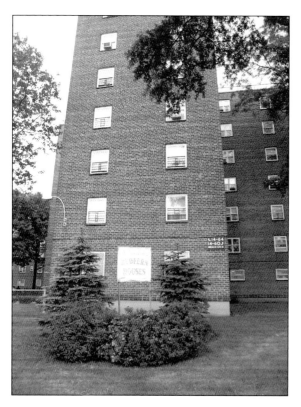

Calling for "less mechanical noise-making and amusement devices," Moses razed hotels, rooming houses, and bungalows in the Rockaways. Ironically, they were replaced with sprawling publicly funded housing that concentrated the poor. The Redfern Houses were among the first built in Far Rockaway in the 1950s. (Courtesy Daniel Hendrick.)

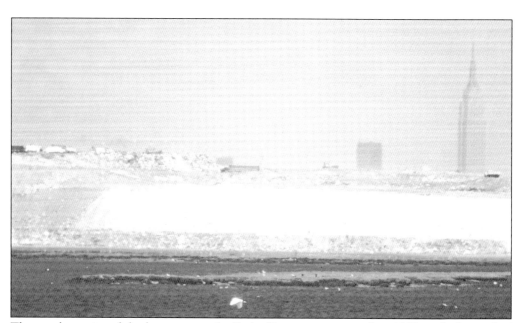

The northern rim of the bay came under Parks Department control in 1949, with the goal of replacing the salt marshes and tidal shallows with parks. To accomplish this, Moses allowed enormous garbage dumps to rise over the next two decades between the Belt Parkway and the bay. (Courtesy Don Riepe and American Littoral Society.)

Moses linked his vision of the city's largest recreation area with the construction of sewage treatment plants. With his support, four were built, at Coney Island, Jamaica, the 26th Ward, and Rockaway. The Rockaway plant, above, was the last to open, on August 7, 1952, at a cost of $6 million. (Courtesy New York City Department of Sanitation.)

Moses's crowning achievement was the creation of Jamaica Bay Park, now known as the Jamaica Bay Wildlife Refuge. East Pond (100 acres) and West Pond (45 acres) were created with the belief that freshwater environments better served the migrating waterfowl. (Courtesy National Park Service.)

The sprawling Jamaica Bay Houses, to the north of Canarsie Pier and the Belt Parkway, were built in 1946 as emergency housing for veterans returning from World War II. More than 8,000 people lived in the complex, which closed in 1954 to make way for the Bay View Houses, a public housing project. (Courtesy Brooklyn Public Library, Brooklyn Collection.)

At the foreground of this 1961 photograph, lots had been cleared for the Seaside Title I Housing Project. The complex is known today as Dayton Towers and is typical of the drab but solid high-rises Moses built on the Rockaway Peninsula. (Courtesy Queens Borough Public Library, Long Island Division, Illustrations Collection.)

Five

AVIATION

The association between aviation and Jamaica Bay dates back to 1917 and the United States' entry into World War I. Deeming it necessary to protect New York Harbor from submarines and naval vessels, the Navy built Rockaway Naval Air Station on what is now the western half of Jacob Riis Park. Various types of "flying boats," or seaplanes, were built, maintained and stationed at hangars and support facilities. A large hangar at the eastern end housed hydrogen-filled dirigibles used for anti-submarine patrols.

It was from a launching ramp that extended into the bay that the NC-4 seaplane began its history-making flight across the Atlantic. With a wooden frame and four Liberty V-12 engines, the NC-4 and sister ships NC-1 and NC-3 took off at 10:00 a.m. on May 8, 1919. First traveling to Nova Scotia, the seaplanes were guided toward Plymouth, England, with the help of navy destroyers spaced along their route. The NC-1 landed at sea and sank, while the battered NC-3 drifted into the Azores. On May 31, 1919—after more than 57 hours of actual flight time—the NC-4 and its six-member crew completed the journey of nearly 4,000 miles.

On May 23, 1931, Floyd Bennett Field opened as New York City's first municipal airport. Located on Barren Island, the airfield was one of the most modern in the world, but the lack of easy access from Manhattan and loss of an airmail contract to Newark made it a commercial failure. After LaGuardia Airport opened in 1939, New York City began to look for a buyer. The navy paid $9 million two years later, and Floyd Bennett became the busiest naval air station in the country during World War II.

Jamaica Bay's prominence in civil aviation was cemented by the opening of New York International Airport to commercial flights in July 1948. Located on what had been the Idlewild Golf Course and Jamaica Sea Airport, the new airport required $150 million in initial construction costs. It was rededicated on December 24, 1963, as John F. Kennedy International Airport, and is one of the world's busiest airports today.

Rockaway Naval Air Station opened in 1917 on 97 acres of land used by permission of the New York City Parks Department. Along with newly built Fort Funston (later Fort Tilden) immediately to the west, the naval air station marked the second time the Rockaway's western shores were used for military purposes. The first was a wooden blockhouse with a single cannon installed to keep the British out of the bay during the War of 1812. (Courtesy Queens Borough Public Library, Long Island Division.)

Hydrogen-filled dirigibles moored at masts near a hangar on the eastern side of the base. At its height, there were 125 officers and 1,160 enlisted men stationed at the naval air station. The base closed in 1930. (Courtesy Queens Borough Public Library, Long Island Division.)

Rockaway Naval Air Station crews prepare the NC-4 on May 8, 1919, for takeoff on the first successful transatlantic flight. Designed by Glenn Hammond Curtis, the NCs were the largest and most advanced aircraft of the day. Seen in the distance are the Barren Island factories. (Courtesy Library of Congress.)

The NC-4 arrives at Ponta Delgada, in the Azores, on May 20, 1919. The crew was greeted like heroes and treated to a magnificent banquet by the Azores governor, where the wine flowed freely and there were many toasts. (Courtesy Library of Congress.)

The crew of the NC-4 meets with Adm. Richard Jackson, far right, after the successful flight to Ponta Delgada. From left to right are Lt. Elmer Stone, the pilot; chief machinist mate Eugene Rhoads; Lt. Walter Hinton, copilot; Ens. Herbert Rodd, radioman; Lt. James Breese, engineer; and Lt. Commander Albert Read, the skipper and navigator. (Courtesy Library of Congress.)

After the NC-1 flew off course and later sank (its crew was rescued by a passing ship), the damaged NC-3 limped into Ponta Delgada on May 19. (Courtesy Library of Congress.)

Floyd Bennett (1890–1928) was a true hero of early American aviation history. He enlisted in the U.S. Navy in 1917, becoming a mechanic, a flight instructor, and later a courageous pilot for Comdr. Richard E. Byrd. He died after contracting an illness during a mission to rescue fellow aviators in Labrador. (Courtesy Library of Congress.)

This c. 1927 photograph offers a rare view of the Jamaica Sea Airport, located on the bay's northeastern shore near the Nassau County line. The aircraft is a Curtiss Jenny, built in Hammondsport, New York. The airport was one of several landing strips around the bay in the 1920s and 1930s, and had one tin hangar and three runways. It was leveled to create Idlewild Airport in 1942. (Courtesy Cradle of Aviation Museum.)

Among the many record-breaking flights that ended or began at Floyd Bennett was that of Wiley Post in 1933. With help from the newly developed autopilot and radio compass, he was the first to fly solo around the world, completing the flight in seven days, 19 hours aboard the *Winnie Mae*. (Courtesy National Park Service.)

CITY OF NEW YORK
MUNICIPAL AIRPORTS
NO.1 FLOYD BENNETT FIELD · NO. 2 NORTH BEACH
EAST RIVER SEAPLANE BASES WALL STREET —— 31ST STREET
F.H.LaGUARDIA JOHN McKENZIE
MAYOR COMMISSIONER OF DOCKS

A Works Progress Administration poster promotes New York City's two municipal airports. The opening of North Beach Airport (later renamed after Mayor Fiorello LaGuardia) in 1939 spelled the demise of Floyd Bennett as a commercial airport. (Courtesy National Park Service.)

After World War II, the F4U was one of the most common training airplanes at Floyd Bennett. Its distinctive bent wing design allowed the large propeller to clear the deck of an aircraft carrier while boosting the top speed. (Courtesy National Park Service.)

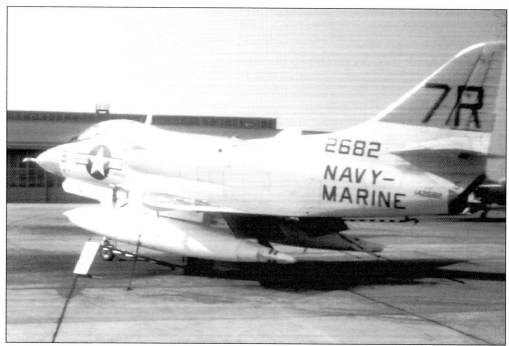

An A4-B is parked outside Hangar B in 1965. The red tail wing noted that the plane was used for training, while the "7R" meant it belonged to a reserve unit at Floyd Bennett. (Courtesy National Park Service.)

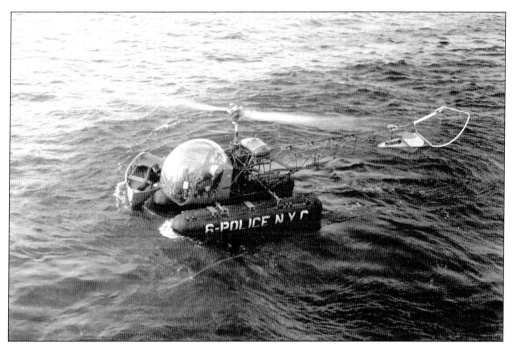

The New York Police Department's aviation unit has been located at Floyd Bennett since 1936. The unit was founded in 1929, and is the oldest police aviation unit in the world. Here, police practice a water rescue in the 1950s. (Courtesy National Park Service.)

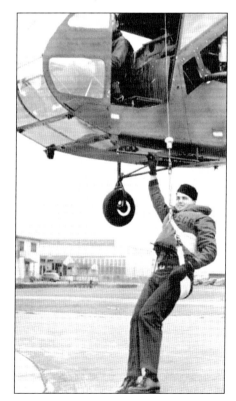

As the largest training center of its kind, the New York Police Department's Helicopter Unit at Floyd Bennett Field was at the forefront of new technologies. Here Sergei Sikorsky, son of helicopter pioneer Igor Sikorsky, tests the first helicopter rescue winch in 1945. (Courtesy National Park Service.)

Over its three decades of service to the armed forces, many experimental and advanced-design aircraft visited Floyd Bennett. Here, a Lockheed Constitution/R6Vs is parked outside Hangar B in the 1950s. It remains the largest aircraft ever operated by the U.S. Navy. (Courtesy National Park Service.)

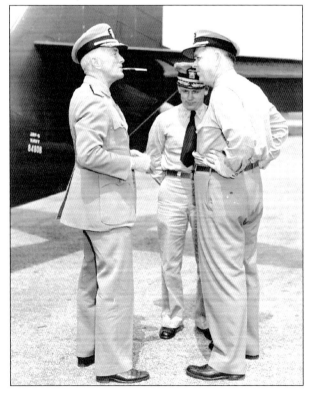

Adm. Richard E. Byrd visits Floyd Bennett Field in the mid-1950s. The famed aviator had a special connection to the field; it was named after the chief pilot on his first flight to the Antarctic in 1926. (Courtesy National Park Service.)

This 1938 aerial view of Floyd Bennett Field looks south, showing runways, hangars, and the administration building, where the control tower was located. The road at right is Flatbush Avenue, which borders Dead Horse Bay. The U.S. Navy deactivated the field in 1971, and later transferred it to the National Park Service. (Courtesy National Park Service.)

Floyd Bennett served as a secure facility for presidential visits, including one by Pres. Richard M. Nixon. In the early 1960s, Pres. John F. Kennedy's *Air Force One* blew a tire upon landing; he later sent the response crews a keg of beer and several bottles of whiskey with his thanks. (Courtesy National Park Service.)

U.S. Rep. William F. Ryan (Democrat for New York) was the leading advocate for creating Gateway National Recreation Area, which includes Floyd Bennett Field. The field's visitors center, formerly the main terminal, is named after him. He died in 1972. (Courtesy National Park Service.)

An aerial view of New York International Airport from a 1945 edition of the *New York Herald-Tribune* calls for eight intersecting runways, marine hangars on the west, and factories on the east. Originally planned for 1,000 acres, the airport has since grown to five times that size. (Courtesy Queens Borough Public Library, Long Island Division, New York Herald-Tribune Photo Morgue.)

The light color of the airport construction zone reflects the use of sand dredged from Grassy Bay as fill material. The airport was rededicated on December 24, 1963, as John F. Kennedy International Airport (JFK). (Courtesy Queens Borough Public Library, Long Island Division, Chamber of Commerce of the Borough of Queens Records.)

This aerial view shows the city-built temporary administration and passenger terminal in December 1947. The building was the sole terminal at New York International Airport—code letters IDL—until 1957, when the International Arrivals Building opened. (Courtesy Queens Borough Public Library, Long Island Division, Chamber of Commerce of the Borough of Queens Records.)

The Civil Aeronautics Administration, the forerunner to the Federal Aviation Administration, maintained three controllers positions at New York International Airport. Shown in the 11th floor control cab are project engineer Vincent Galotti, left, and radio technician Raymond Campion in 1948. That year, controllers guided 81,115 plane movements, for a total of 222,620 passengers and 5,730 tons of cargo and airmail. (Courtesy Queens Borough Public Library, Long Island Division, Chamber of Commerce of the Borough of Queens Records.)

The Port of New York Authority tests what were deemed to be the world's most powerful all-weather lights at New York International Airport on June 11, 1948. (Courtesy Queens Borough Public Library, Long Island Division, Chamber of Commerce of the Borough of Queens Records.)

Port of New York Authority director Austin Tobin addresses a crowd from the tarmac at New York International Airport in July 1948. The occasion was the arrival of the first scheduled airline flight, flown by Peruvian International Airways. (Courtesy Queens Borough Public Library, Long Island Division, Chamber of Commerce of the Borough of Queens Records.)

As the premier destination airport for many international flights, especially from Europe, JFK has been the gateway for countless business tycoons, movie stars, and world leaders entering the United States. Among them was Soviet Premier Nikita Khrushchev, who landed here on September 15, 1959, for an appearance at the United Nations. (Courtesy Queens Borough Public Library, Long Island Division, Chamber of Commerce of the Borough of Queens Records.)

Finnish architect Eero Saarinen designed the distinctive TWA Terminal, in the right foreground, which opened in 1962. The sloped wings and spacious halls were deliberately chosen to create a lofty, soaring feel. The building is being partially dismantled for inclusion in a new terminal. (Courtesy Queens Historical Society.)

New York International Airport's reputation for innovative architecture did not stop at the terminals. This 1963 artist's rendering shows the Three-Faith Chapel Plaza, planned for a lagoon at the airport's International Park, for the Jewish, Protestant, and Catholic faiths. (Courtesy Queens Borough Public Library, Long Island Division, New York Herald-Tribune Photo Morgue.)

Faced with an increasing demand for air travel and limited space, the Port Authority sought to expand JFK in the late 1960s. The most sweeping proposal called for two new runways and the extension of a third into the bay. The plan was ultimately scuttled in the face of vociferous opposition from elected officials and residents, many of whom would have been displaced. (Courtesy Port Authority of New York and New Jersey.)

The Concorde is brought into a hangar at JFK after arriving on a test flight on October 19, 1977. The flight was not Concorde's first to the United States—a prototype landed in Dallas in 1973 and service first began to Washington, D.C., in May 1977. Once regular Concorde flights began at JFK in November 1977, the airport would conduct more supersonic operations than any other. (Courtesy Queens Borough Public Library, Long Island Division, Joseph A. Ullman Photographs.)

Just moments after takeoff from JFK's runway 31L, American Airlines Flight 587 crashed into the Belle Harbor section of the Rockaways en route to the Dominican Republic on the morning of November 12, 2001. The crash killed all 251 passengers, 9 crew members, and 5 people on the ground. The toll would have been worse if the Airbus 300 had crashed at a less-steep angle. It was the worst crash in JFK's history. (Courtesy New York Police Department.)

Six

LIFE ON JAMAICA BAY

Jamaica Bay is located on the periphery of New York City and occupies a similar place in its consciousness. The old population centers of Brooklyn and Manhattan have long dominated the city's politics and culture, while the bay, situated in the most remote corners of Brooklyn and Queens, has embraced the antithesis of urban life.

From the earliest days of European settlement, it was the more adventurous souls who found their way here. Abundant and cheap land was the initial attraction for farmers growing potatoes, corn, and winter wheat. In later years, entrepreneurs put their savings toward boats and equipment to harvest oysters and clams. Eventually people flocked to its shores seeking respite and open space. Some lived in hotels, bungalows, and tents for the summer. Others stayed on year-round in simple shacks built on stilts. The charms of living near the water are obvious: boating, fishing, and fresh air. Less heralded are the perils, like hurricanes and nor'easters that lash homes off their foundations and the constant threat of floods.

For all its wildness, Jamaica Bay remains part of a major world city. The collision of man with nature yields strange ironies, like swimming on a hot day near Broad Channel when a locomotive steams past. The population has swollen and diversified along with the rest of the city. African Americans, Latinos, South Asians, Orthodox Jews, and West Indians now share neighborhoods where Italians, Germans, and Irish predominated in the early 20th century. By living, playing, and working on its shores, each successive generation develops a relationship with the bay and adapts it to their needs.

With its wide open spaces and unhurried pace, it is easy to forget that Jamaica Bay is part of the largest city in the United States—until a subway car or airplane appears. Here, two women bathe as the Long Island Rail Road steams over the trestle in 1914. (Courtesy Queens Borough Public Library, Long Island Division.)

A family relaxes at the Idle Hour, a summertime cottage in Meadowmere in 1900. The tiny hamlet is located in a loop of Hook Creek past the end of Head of Bay in Rosedale. (Courtesy Queens Borough Public Library, Long Island Division, George W. Winans Collection.)

Sam Hirst, left, and John Boll fish on a creek before the beginning of the 20th century, perhaps near the land Hirst owned on the northern shore. The bay was known for its excellent fishing, which still attracts anglers to legendary spots like Silver Hole Marsh. (Queens Borough Public Library, Long Island Division.)

For the many sportsmen who flocked to Jamaica Bay, fishing offered endless opportunities for rowing, fishing, and relaxing. Here, a man empties crab traps around 1900. His white shirt and tie suggest he does not fish for a livelihood. (Courtesy Queens Borough Public Library, Long Island Division, Illustrations Collection.)

Due to its distance from the hubbub of city life, Broad Channel has long been known for its village atmosphere and leisurely pace. Here, a family relaxes in their Broad Channel cottage in 1915. (Courtesy Library of Congress.)

Discarded bottles recovered from the bay offer a quotidian perspective on life in the 19th and early 20th centuries. Most of the glass bottles held beer and soda, while the ceramic jugs contained ginger beer and the small bottles were used for medicines. (Courtesy Emil Lucev.)

The Rockaways, especially Far Rockaway, attracted an aristocratic crowd before railroads took them farther out on Long Island. But by 1903, when this photograph was taken of a Rockaway tent city facing the bay, the peninsula was clearly a vacation spot for the less affluent. (Courtesy Library of Congress.)

Bungalows created a working-class Riviera in the Rockaways in the 1920s. The one-and-a-half-story houses had front porches and pitched roofs, with permanent easements for common walkways to the beach. Many of the bungalow colonies were later razed for public housing or urban renewal projects, and are becoming increasingly rare. (Courtesy Library of Congress.)

Anna and Elwood Yoepp play near a creek outside their Idlewild home in 1939. The enclave near the Nassau County border was predominated by blue-collar and civil service families. (Courtesy Keim, Yoepp, and Kress families.)

Originating as a cluster of homes off Old Foster's Meadow Road, Rosedale grew rapidly in the 1920s and 1930s at Queens's easternmost edge. Residents like Eileen Veith Mulvey recall the neighborhood as a tight-knit "shangri-la," that offered proximity both to New York City and the open spaces of Long Island. She is seen here in 1941, ice skating on Conselyea's Pond in Brookville Park. (Courtesy Eileen Veith Mulvey.)

Religion has long played a central role in tight-knit Broad Channel, where St. Virgilius Mission Church, dedicated in 1914, continues to serve as a spiritual and community hub to this day. Shown is St. Virgilius School's first graduating class on June 24, 1927. From left to right, they are Henrietta Harnisher (née Buchheit), James Hudson, and Evelyn Rossi (née Goemans) with Fr. Joseph Curran. Declining enrollment prompted the Diocese of Brooklyn to close the school at the end of the 2005–2006 school year. (Courtesy Evelyn Goemans Rossi and Broad Channel Historical Society.)

The most celebrated of Jamaica Bay's many boat races occurred on August 10, 1947, when big-band leader Guy Lombardo participated in the International Gold Cup Race. Danny Foster's *Miss Pepsi V* won, while Lombardo's *Miss Tempo VI* placed third. Rumor has it he hit a piece of driftwood. (Courtesy Emil Lucev.)

Members of Broad Channel's Nut Club pose for a photograph near Dutch's barn in 1934. The team's main rivals were the Cardinals, also based on the island. (Courtesy Joe Carey and Broad Channel Historical Society.)

Trails and undeveloped areas near Brooklyn's Spring Creek offered young people a place to socialize and recreate. Here, Joseph and Helen Lanzone show off their new Harley Davidson 74 cubic near the creek in the early 1950s. (Courtesy Joseph and Helen Lanzone.)

The Harrie Currie Nickel Pitch was one of dozens of amusements that attracted the working- and middle-class masses to Rockaway Playland for more than 80 years. The park finally closed in 1986 when the owner could not afford a steep increase in the liability insurance premium. A new housing development now occupies the site. (Courtesy Queens Historical Society.)

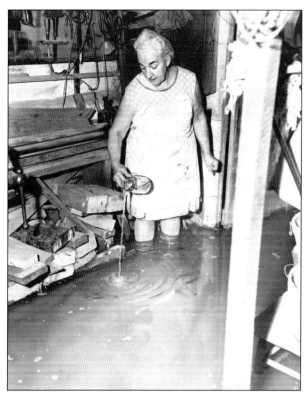

Residents of Southern Queens must cope with frequent flooding because of the flat topography near Jamaica Bay. Seen here after a March 1951 storm, Mrs. Charles Kletty confronts a flooded basement in her home at 144-37 153rd Lane in Rosedale. (Courtesy Queens Borough Public Library, Long Island Division, Illustrations Collection.)

Residents living on the bay are all too familiar with the perils of strong storms and hurricanes. Here, a nor'easter swamps a home near Beach 69 Street in Rockaway on December 11, 1992. (Courtesy Russell family.)

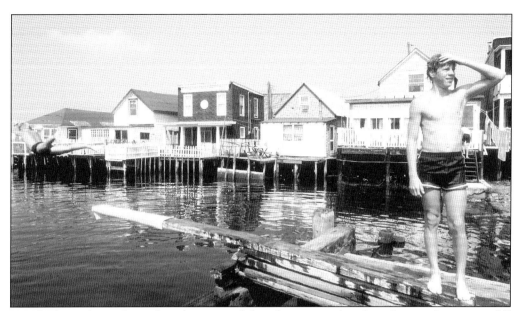

Broad Channelites often take advantage of their location to kayak and swim. Swimming fell out of fashion on the bay in the 1920s, but water quality has improved since the 1972 Clean Water Act and upgrades at sewage treatment plants. (Courtesy Don Riepe and American Littoral Society.)

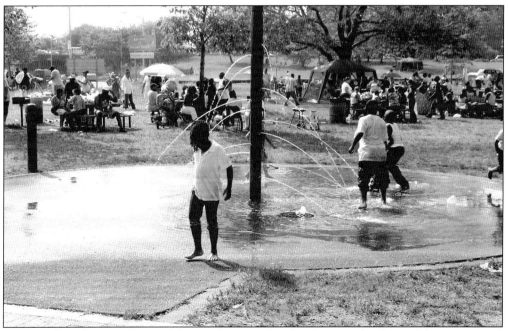

The crowds at Canarsie Pier on Memorial Day weekend underscore the demand for recreational facilities on the highly urbanized Brooklyn shore. Irish, Italian, and Jewish residents dominated Canarsie in the early and mid-20th century; the neighborhood now counts many Caribbean and Hispanic residents. (Courtesy Daniel Hendrick.)

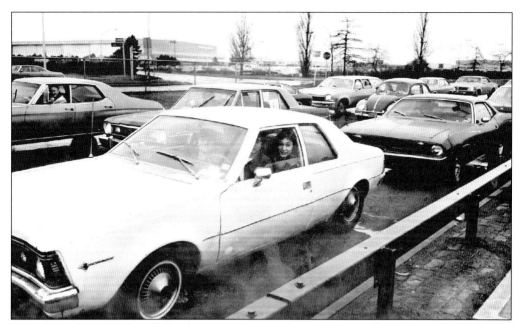

Already bombarded by hundreds of noisy airplanes each day, angry residents demonstrated against the Concorde by blocking traffic at JFK on February 22, 1976. Their efforts were successful for a while. A federal and New York City ban kept the supersonic tansport (SST) from scheduling service at JFK until November 22, 1977. (Courtesy Queens Borough Public Library, Long Island Division, Joseph A. Ullman Collection.)

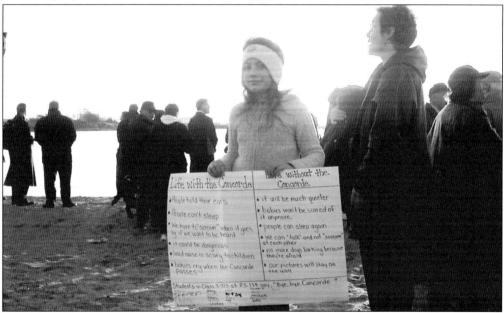

The Concorde made its final departure from JFK on October 24, 2003, to London's Heathrow Airport, ending the era of transatlantic supersonic passenger travel. That morning, residents gathered in Frank M. Charles Memorial Park in Howard Beach to bid the SST farewell—and good riddance, according to many who lived along the flight path. (Courtesy Bryan Joiner and Queens Chronicle.)

Seven

ENVIRONMENTAL RECKONING

The conclusions of a 2000 study by New York state officials were alarming: Jamaica Bay's salt marshes are rapidly drowning in place, unable to keep pace with the rising sea. The loss is accelerating, reaching 44 acres lost per year in 1999, and researchers warned that the wetlands could disappear entirely by 2020 if no action were taken. The news sent shock waves through residents and environmentalists, since the loss would expose homes to erosion and destroy habitat for the bay's renowned wildlife refuge.

The list of possible causes for the loss catalogued the environmental abuses inflicted on Jamaica Bay since the beginning of the 20th century. Dredging has vastly altered the bay floor, changing the way water flows in and out. Landfill to create homes and reshape islands has blocked streams, while artificial bulkheads fenced the marshes in. Four sewage treatment plants dump 250 million gallons of wastewater each day, suffocating fish with nitrogen and making all shellfish inedible. Three hazardous waste dumps leak toxic ooze and rain washes chemicals into the bay from streets and JFK. The net result is that the bay has nearly halved in size, encompassing 24,000 acres in 1900 and 13,000 acres in 1970.

Planners in the 19th and early 20th century did not understand the value of wetlands. But early on, it was clear that Jamaica Bay was a place for all things unwanted, whether it was a horse-rendering factory, garbage dumps, or a noisy airport. Robert Moses began reversing that trend in the 1930s and others have followed to this day. Court orders recently compelled the city to curb sewage dumping and the federal government is restoring some marshes. Environmental officials and residents are also drawing up plans to protect Jamaica Bay's watershed in a more comprehensive way.

A Division of Street Cleaning ash truck heads for final disposal in 1908. In addition to garbage and sewage sludge, ashes were widely used as fill material to reclaim land for homes and parks on the bay. (Courtesy New York City Department of Sanitation.)

A giant steam shovel fills in Hook Creek near Meadowmere Park around 1900. Dredging and filling has vastly altered the bay's shape and hydrology, cutting off streams and stopping the natural migration of wetlands. (Courtesy Queens Borough Public Library, Long Island Division, George W. Winans Collection.)

Sewage led to the bay's earliest environmental setback. In 1904, oysters caught off Inwood were linked to 21 cases of typhoid, followed 11 years later by another 27 cases from Canarsie oysters. By 1917, when this illustration was published, 50 million gallons of sewage flowed into the bay each day. Health officials closed the shellfish beds in 1921, and the practice remains banned to this day. (Courtesy Queens Magazine.)

Gerritsen Creek is one of several basins that were altered or created as part of a plan to turn Jamaica Bay into a massive port during the early 20th century. Dredging changed the waterways' natural flow, rendering some of them stagnant and foul-smelling. (Courtesy Don Riepe and American Littoral Society.)

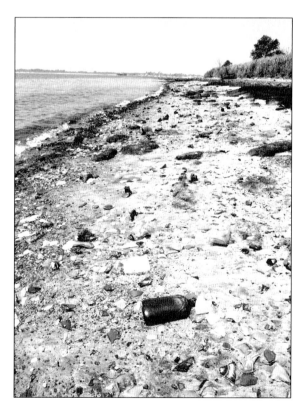

Beginning in the late 19th century until 1914, Barren Island was the final resting place for millions of tons of garbage from the Bronx, Brooklyn, and Manhattan. To this day, the island's eastern shore is littered with so much glass that waves tinkle as they crash. Erosion of the island carries some of the ancient refuse into the bay. (Courtesy Daniel Hendrick.)

LEGEND
● EXISTING
▲ PROPOSED

CITY OF NEW YORK
DEPARTMENT OF SANITATION

SANITARY LANDFILLS

This 1950 map illustrates the disproportionate number of sanitary landfills at Jamaica Bay. Of the eight in use at the time in New York City, four were on the bay—Marine Park, Pennsylvania Avenue, Spring Creek, and Edgemere—and a fifth was proposed for Idlewild Park, on the northeastern shore. (Courtesy New York City Department of Sanitation.)

A 1956 artist's rendering shows a planned expansion of the Jamaica Water Pollution Control Plant, from 65 million to 100 million gallons a day. Today, the four plants on the bay can treat up to 340 million gallons of waste each day. The solid sludge is shipped away for fertilizer, while the effluent is released into the bay. (Courtesy New York City Department of Sanitation.)

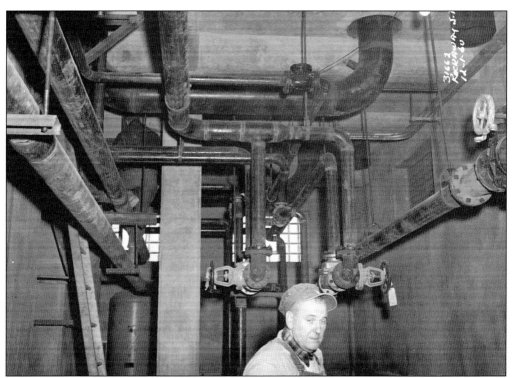

A worker mans the pump and powerhouse extension at the Rockaway Water Pollution Control Plant in December 1960. The pumps are part of the complex engineering system that moves waste through the treatment process and adds oxygen to stimulate breakdown by bacteria. (Courtesy New York City Department of Environmental Protection.)

Barges install a new sewer outfall at the Rockaway Water Pollution Control Plant in January 1975. The pipe is several hundred feet long, to avoid concentrating the wastewater in any one location of the bay. (Courtesy New York City Department of Environmental Protection.)

Workmen at the Rockaway Water Pollution Control Plant remove digested sludge from a tank in March 1974. The tanks are periodically cleaned to remove inert sediment. (Courtesy New York City Department of Environmental Protection.)

This view looks south toward aeration and settling tanks at Brooklyn's 26th Ward Water Pollution Control Plant in 1971. In the background is the bay. The plant processes up to 85 million gallons of waste a day; during emergency repairs and blackouts, a bypass sends the waste into the bay untreated. (Courtesy New York City Department of Environmental Protection.)

Sanitation Department workers clean a stretch of Brookville Boulevard, known to locals as Snake Road, in the 1960s. The Idlewild Park wetlands at left, which drain into the bay, are routinely dumped upon. Every so often, dead bodies are found disposed there. (Courtesy New York City Department of Sanitation.)

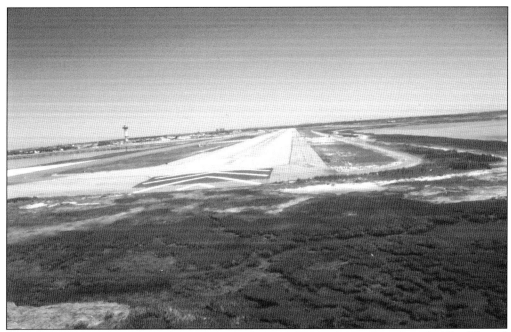

JFK's Runway 4L-22R is more than two miles long, and extends into Joco Marsh. The fill used for the runway came from nearby Grassy Bay, which was dredged nearly 50 feet deep. Scientists suspect that diesel fuel and airplane deicing fluid are harming the bay. (Courtesy Don Riepe and American Littoral Society.)

Sanitation Department trucks empty their loads at the Fountain Avenue landfill in 1973. The 297-acre site opened in the 1950s and closed in 1985, after months of angry protests by residents of East New York and Canarsie. (Courtesy Don Riepe and American Littoral Society.)

The Edgemere Landfill was located in the Bayswater section of the Rockaways. Beginning in 1938, it took in an average of 1,200 tons of solid waste each day. From 1975 to 1979, hundreds of thousands of gallons of hazardous materials were also dumped there. (Courtesy Don Riepe and American Littoral Society.)

Since New York City's sewers combine sanitary waste and rainwater, they are overwhelmed during even the slightest shower. The overflow of untreated waste flows into the bay at dozens of locations, including Fresh Creek, above. Special netting called a "boom" retains floatable and other debris. (Courtesy Don Riepe and American Littoral Society.)

This fishkill was observed off Broad Channel in 1998. Low levels of oxygen in the water are a problem throughout the bay, particularly in inlets where sewers discharge untreated waste. (Courtesy Don Riepe and American Littoral Society.)

Brooklyn's 1.25-mile-long Paerdegat Basin, where several sewer overflows terminate, is one of the least healthy inlets. The city Department of Environmental Protection is building a massive underground tank there to better manage the wastewater, but the project has been delayed several times. (Courtesy Don Riepe and American Littoral Society.)

Sanitation commissioner Steven Polan, in the tie without glasses, and city councilman Walter Ward, the tallest person in the group, joined community leaders and officials to mark the closure of the Edgemere Landfill. The site was remediated and capped under the New York State Superfund program but some hazardous materials leached into the bay. (Courtesy New York City Department of Sanitation.)

A man watches as crews cap the Pennsylvania Avenue landfill in 2003. Robert Moses's plans for the northern shore are finally becoming a reality; the New York City Department of Environmental Protection is transforming the 84-acre site, along with neighboring Fountain Avenue landfill, into public parks. (Courtesy Leander Shelley.)

Fruit litters the beach on the north end of the Jamaica Bay Wildlife Refuge. The material is left behind from Hindu religious ceremonies. The authorities have shown little appetite for enforcing litter laws, for fear of offending religious sensitivities. (Courtesy Don Riepe and American Littoral Society.)

Vincent Oppedisano, the owner of a Queens construction company, dangles from a crane before removing an abandoned car in Idlewild Park in 2002. Ironically, state laws protecting Jamaica Bay wetlands had hindered the cleanup for years. (Courtesy Daniel Hendrick and Queens Chronicle.)

The case of Duck Point Marsh starkly illustrates the wetlands loss at Jamaica Bay. In 1974, the marsh, located south of Spring Creek, encompassed 104 vegetated acres. (Courtesy New York State Department of Environmental Conservation.)

By 1999, Duck Point Marsh had only 38 vegetated acres, the rest being underwater. Between 1974 and 1994, a total of 526 acres of salt marshes disappeared throughout the bay. Over the next five years, another 220 acres were lost—an average rate of 44 acres each year. (Courtesy New York State Department of Environmental Conservation.)

Employing a method used to restore Louisiana's wetlands, engineers sprayed sediment dredged from the bottom of the bay onto Big Egg Marsh in 2003. The goal was to elevate the marshes above the rising sea. (Courtesy Don Riepe and American Littoral Society.)

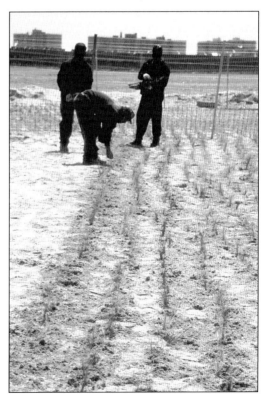

Crews plant native spartina grass on Big Egg Marsh in 2003. The restoration there appeared to meet with tenuous success, although it represents only a fraction of the bay's total losses.(Courtesy Don Riepe and American Littoral Society.)

Stony Creek Marsh epitomizes the deterioration. Wetlands that were flooded twice a day at high tides now remain underwater, drowning the grasses. Once the grasses die, the marsh breaks up and erodes away. (Courtesy Don Riepe and American Littoral Society.)

The Jamaica Bay Watershed Protection Advisory Committee meets in early 2006 at Jamaica's York College. The committee of residents, scientists, and environmentalists was convened the year before to devise long-term solutions to the bay's ecological problems. (Courtesy Daniel Hendrick and Queens Chronicle.)

More than 325 bird species have been observed around Jamaica Bay in the last 25 years, along with endangered fish, butterflies, and plants. This great egret was spotted in Idlewild Park wetlands. (Courtesy Daniel P. Derella.)

A question mark punctuates a depiction of Jamaica Bay by environmental artist Brandon Ballengee. The artwork reflects the many challenges and questions that loom in the bay's future. (Courtesy Brandon Ballengee.)

Discover Thousands of Local History Books Featuring Millions of Vintage Images

Arcadia Publishing, the leading local history publisher in the United States, is committed to making history accessible and meaningful through publishing books that celebrate and preserve the heritage of America's people and places.

Find more books like this at
www.arcadiapublishing.com

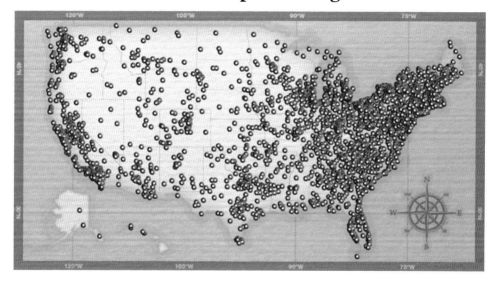

Search for your hometown history, your old stomping grounds, and even your favorite sports team.

Consistent with our mission to preserve history on a local level, this book was printed in South Carolina on American-made paper and manufactured entirely in the United States. Products carrying the accredited Forest Stewardship Council (FSC) label are printed on 100 percent FSC-certified paper.

MADE IN THE USA